FORTUNE FAVORS the BRAVE

100 COURAGEOUS QUOTATIONS
HAND-LETTERED BY LISA CONGDON

CHRONICLE BOOKS
SAN FRANCISCO

To every young girl in the world.
Be brave.

Page 105 constitutes a continuation of the copyright page.

Library of Congress Cataloging-in-Publication Data available.

ISBN 978-1-4521-4410-8

Manufactured in China

Design by Kristen Hewitt

10 9 8 7 6 5 4 3 2 1

Chronicle Books LLC
680 Second Street
San Francisco, CA 94107
www.chroniclebooks.com

"Live! Live the wonderful life that is in you!
Let nothing be lost upon you. Be always searching
for new sensations. Be afraid of nothing."

—Oscar Wilde

When I was thirty-one years old I got two words tattooed on my right arm. Those two words—*truth* and *courage*—lettered inside of banners blowing from the beaks of two barn swallows represented a conscious shift to live my life more authentically. Until that time, throughout my teens and twenties, I spent a lot of time attempting to fit into the mold of who I *thought* I should be and what I *thought* I should do with my life. By the time I was thirty I was bored, uninspired, clinically depressed, and quite truly stuck. And so, in an attempt to be happier, in the few years that followed and until this day (I turned forty-seven this year), it has been my life's work to live every day in ways that feel true and good for me. At the core of this work is the assumption that I cannot be happy or achieve any level of satisfaction in life unless I am living in ways that are aligned with my core values, passions, and temperament—in other words, what I believe in, what makes me feel inspired, and what feels good to me.

Sounds easy enough, right? But it isn't. It takes enormous bravery and determination to be totally yourself, to pursue life dreams that others might not understand, to risk judgment, or to break out of unhealthy relationships, addictions, and habits. It also takes courage to forgive yourself when you falter along the way and to move on after you do or say things you later regret. Let's face it—none of us has a "perfect" path. In fact, accepting, even *embracing*, our missteps and imperfections (including the big ones) is part of the journey. And understanding that we all falter, that we are all beautifully imperfect, and that we are all in some way trying to live authentically connects us as humans.

Over the years, as I have attempted to live a happier, more authentic life, I have relied heavily on the words of other people—writers, thinkers, artists, philosophers, and yes, even regular people—to guide and support my path. Indeed, sometimes reading an inspiring quote in a moment of self-doubt can change my entire outlook and remind me that despite my weaknesses or shortcomings, despite what others might think of me, *I can do this.*

Because I have grown not only to love but also to rely on the wise words of smart people, I have been hand lettering inspirational quotes for several years. I have also found that many people love to read inspiring quotes too, and so I began sharing them on my blog and then in my first book of hand-lettered quotes, *Whatever You Are, Be a Good One.* It felt like the most logical and important step to focus my next book of quotes (the one you are holding in your hands) on *bravery*—the bravery required to live authentically, to be our best selves, to accept our mistakes and shortcomings, and to live, *really live*, a good and happy life.

It is no coincidence that the year I got the words *truth* and *courage* tattooed on my arm was also the same year I started drawing and painting. Living an authentic life meant finding a way to express my deepest fears and my most intense longings. I experimented with all kinds of things during that time—cooking, sewing, writing, new athletic endeavors—all of which I still enjoy today, but making art made me feel thoroughly happy in a way I had never felt before. Many years later, making art has become my entire world, including my livelihood. I am so grateful for every person, every book I have read, and every word that gave me the strength to take risks and fight each wave of self-doubt I encountered.

I hope the brilliant words in this book provide encouragement and motivation for you as you tread the path of your own magnificent journey. May you live bravely and fully!

I SUSPECT THE TRUTH IS THAT WE ARE WAITING, ALL OF US, AGAINST INSURMOUNTABLE ODDS, FOR SOMETHING EXTRAORDINARY TO HAPPEN TO US.

KHALED HOSSEINI

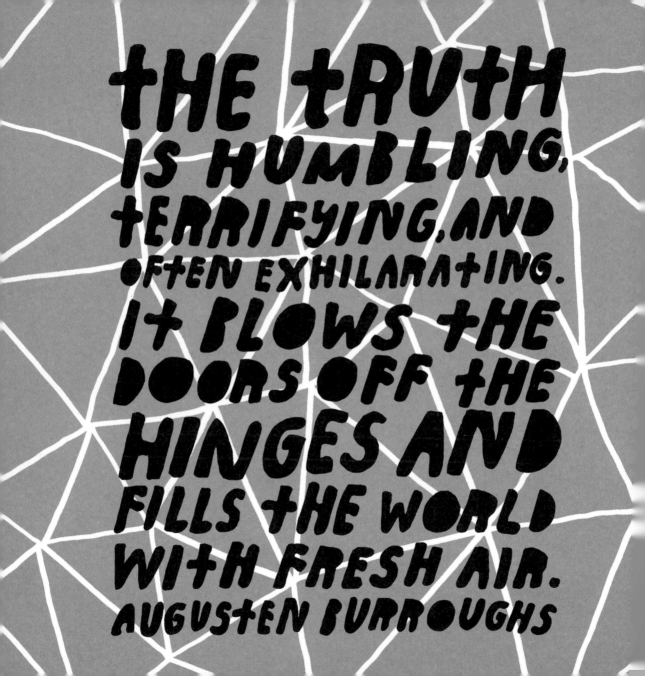

THE TRUTH IS HUMBLING, TERRIFYING, AND OFTEN EXHILARATING. IT BLOWS THE DOORS OFF THE HINGES AND FILLS THE WORLD WITH FRESH AIR.

AUGUSTEN BURROUGHS

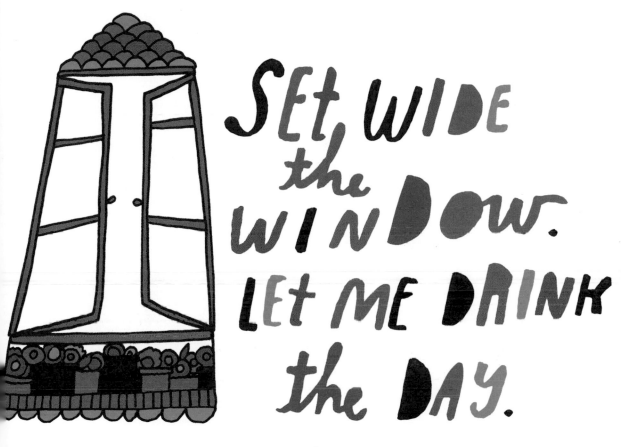

SET WIDE the WINDOW. LET ME DRINK the DAY.

EDITH WHARTON

tHOse who can tRuly BE accounted BRAVE ARE those who BESt know tHE MEANING OF WHAt is SWEEt IN LIFE AND WHAt is tERRIBLE, AND tHEN GO OUt,

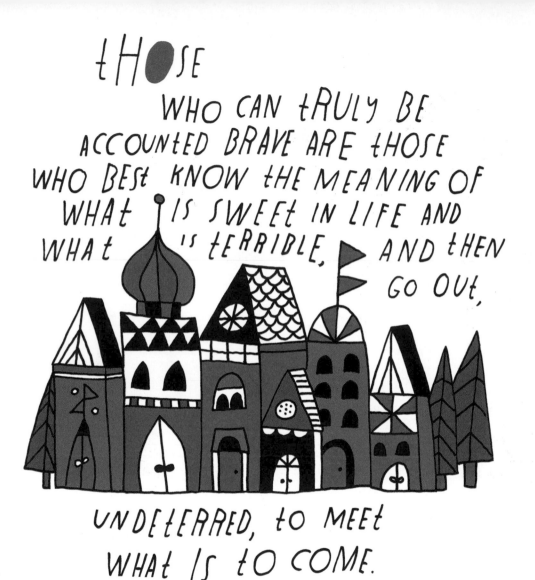

UNDEtERRED, to MEEt WHAt Is tO COME.

PERICLES

TO BE FULLY ALIVE,
FULLY HUMAN,
AND COMPLETELY
AWAKE IS TO BE
CONTINUALLY
THROWN OUT OF THE NEST.
TO LIVE FULLY IS TO
BE ALWAYS IN
NO·MAN'S·LAND,
TO EXPERIENCE EACH
MOMENT AS COMPLETELY
NEW AND FRESH.
TO LIVE IS TO
BE WILLING TO
DIE OVER AND OVER
AGAIN.

PEMA CHÖDRÖN

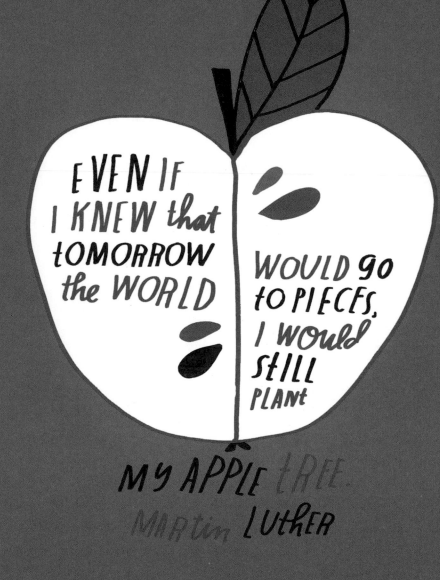

IF I COULD BELIEVE IN MYSELF, WHY NOT GIVE OTHER IMPROBABILITIES

THE BENEFIT OF THE DOUBT?

DAVID SEDARIS

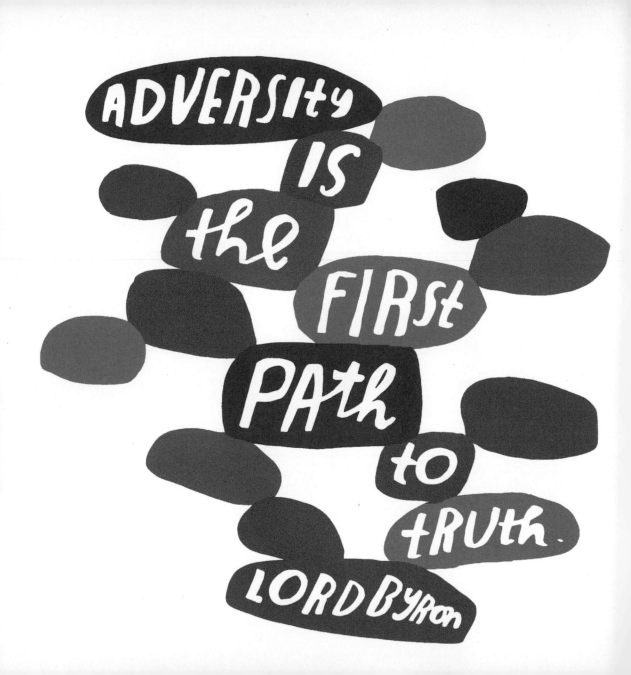

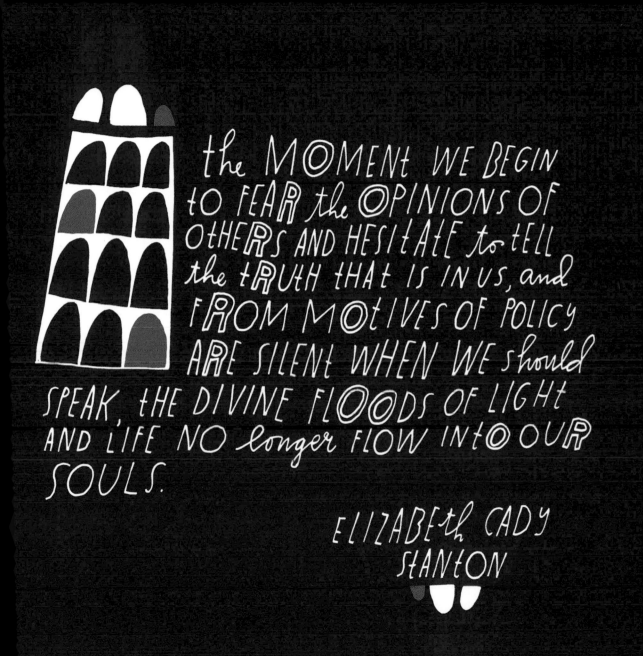

the MOMENt WE BEGIN to FEAR the OPINIONS OF OtHERS AND HESITAtE to tELL the tRUtH tHAt IS IN US, and FROM MOtIVES OF POLICY ARE SILENt WHEN WE should SPEAK, tHE DIVINE FLOODS OF LIGHt AND L'IFE NO longer FLOW INtO OUR SOULS.

ELIZABEtH CADY StANtON

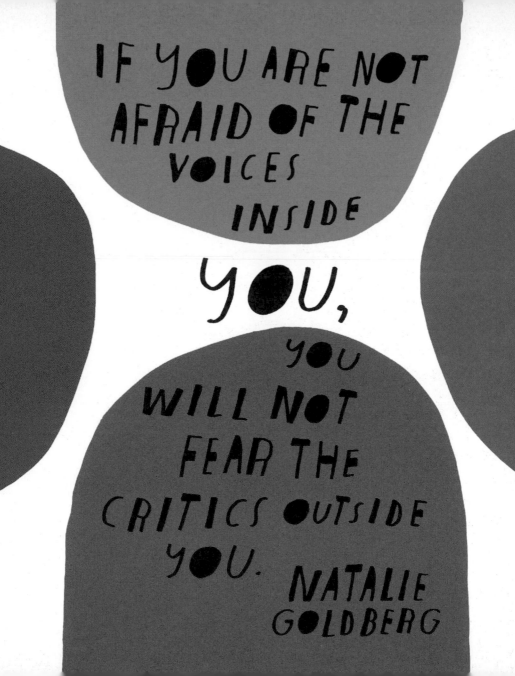

IF YOU ARE NOT AFRAID OF THE VOICES INSIDE YOU, YOU WILL NOT FEAR THE CRITICS OUTSIDE YOU. NATALIE GOLDBERG

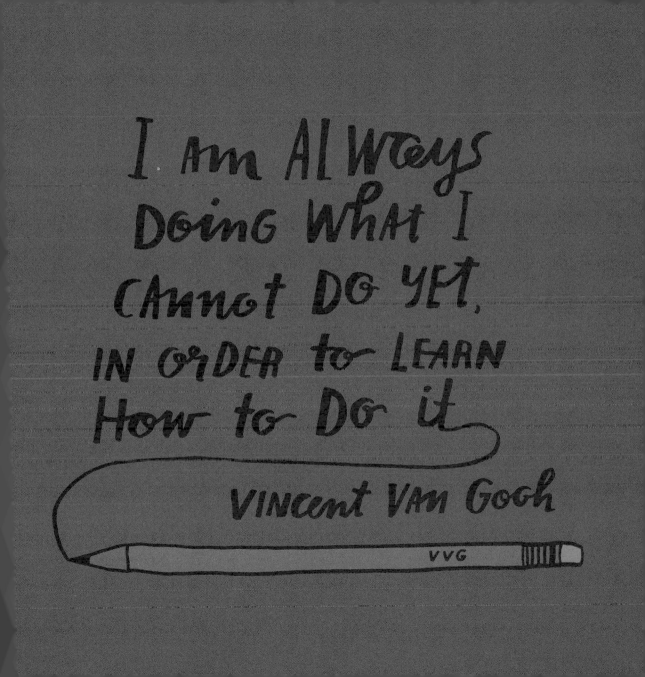

I TRY ALL THINGS;

I ACHIEVE WHAT I CAN.

HERMAN MELVILLE

YOU CAN, YOU SHOULD, AND IF YOU'RE BRAVE ENOUGH TO START, YOU WILL. STEPHEN KING

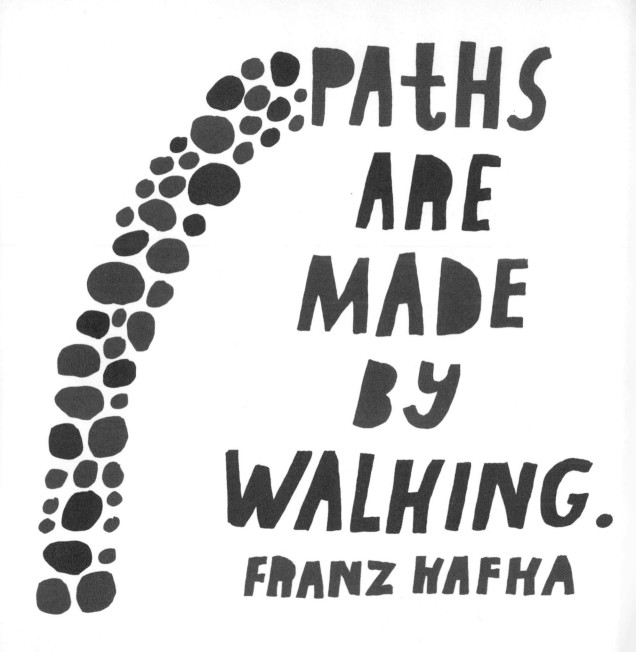

PATHS ARE MADE BY WALKING.
FRANZ KAFKA

ART... IS AN AREA WHERE IT IS IMPOSSIBLE tO WALK WITHOUT StUMBLING. tHERE ARE IN StORE FOR YOU MANY UNSUCCESSFUL DAYS AND WHOLE UNSUCCESSFUL SEASONS: tHERE WILL BE GREAt MISUNDERStANDINGS and DEEP DISAPPOINtMENtS... YOU MUSt BE PREPARED FOR ALL tHIS, ACCEPt It & NEVERtHELESS, StUBBORNLY, FANAtICALLY FOLLOW YOUR OWN WAY. ANtON CHEKHOV

I HAVE BEEN BENT AND BROKEN, BUT — I HOPE — INTO A BETTER SHAPE.

CHARLES DICKENS

LIFE IS NOT EASY FOR ANY OF US, BUT WHAT OF THAT? WE MUST HAVE PERSEVERANCE AND ABOVE ALL confidence IN OURSELVES. WE MUST BELIEVE THAT WE ARE GIFTED FOR SOMETHING AND that this THING, AT WHATEVER COST, MUST BE attained.

MARIE CURIE

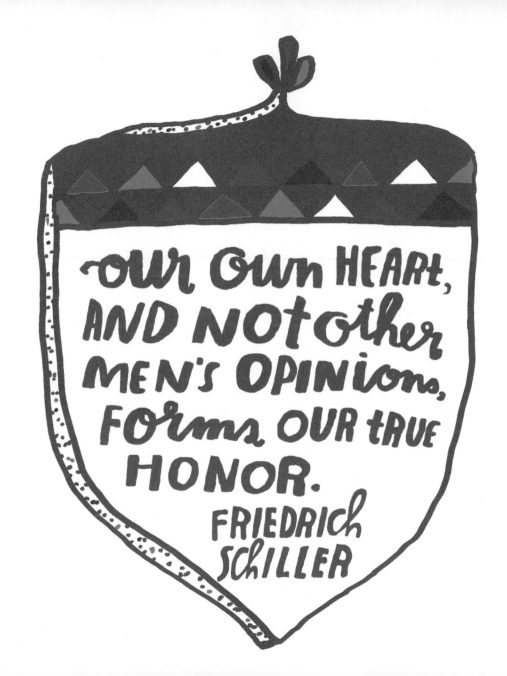

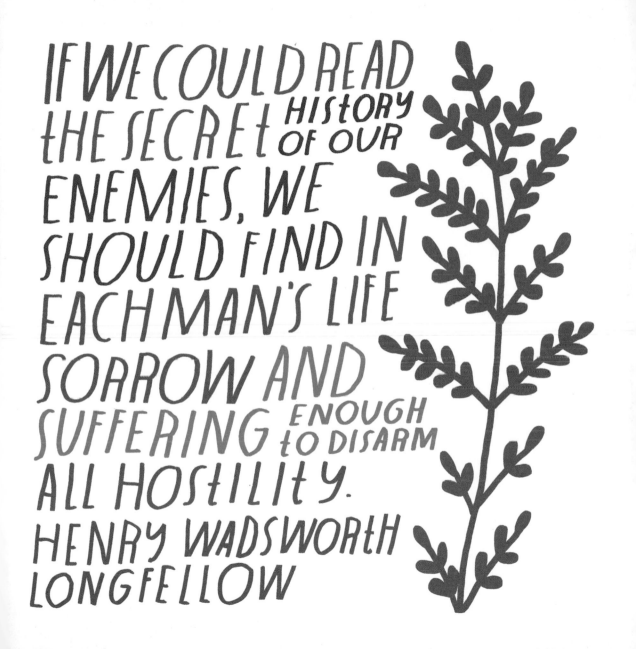

IF WE COULD READ THE SECRET HISTORY OF OUR ENEMIES, WE SHOULD FIND IN EACH MAN'S LIFE SORROW AND SUFFERING ENOUGH TO DISARM ALL HOSTILITY.

HENRY WADSWORTH LONGFELLOW

One should go easy on smashing other people's lies. Better to concentrate on one's own.

IRIS MURDOCH

WHAT SHOULD I BE BUT JUST WHAT I AM?

EDNA ST. VINCENT MILLAY

Don't look at your feet to SEE IF you are Doing It RIGHT.

JUst Dance.

ANNe LAMOtt

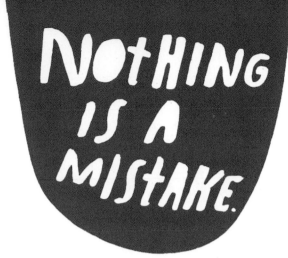

NOTHING IS A MISTAKE.

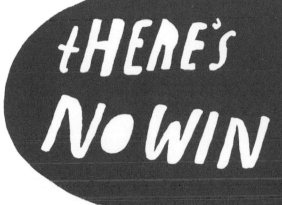

tHERE'S NO WIN

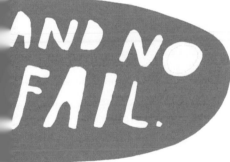

AND NO FAIL.

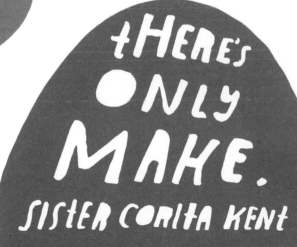

tHERE'S ONLY MAKE.

SISTER CORITA KENT

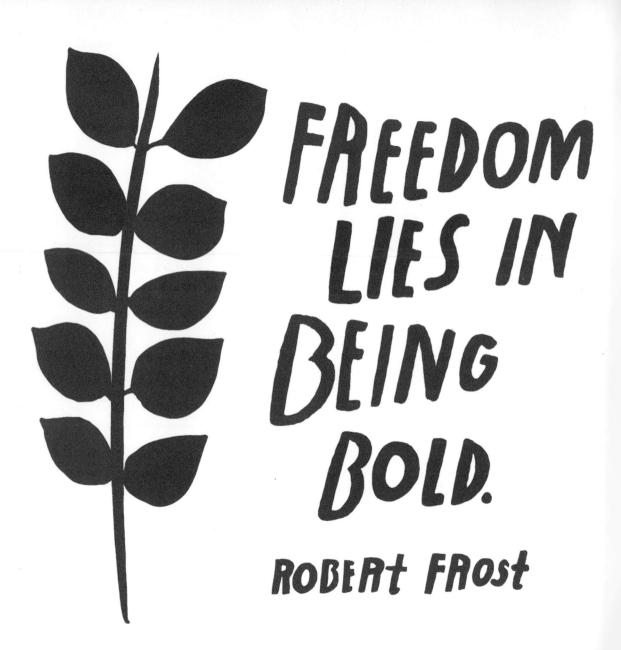

FREEDOM LIES IN BEING BOLD.

ROBERT FROST

ONLY THOSE WHO WILL RISK GOING TOO FAR

CAN POSSIBLY FIND OUT HOW FAR ONE CAN GO.

t.s. ELIOt

IF I CAN'T STAY WHERE I am, And I CAN'T, then I WILL Put ALL that I CAN Into tHE GOING. JEANETTE WINTERSON

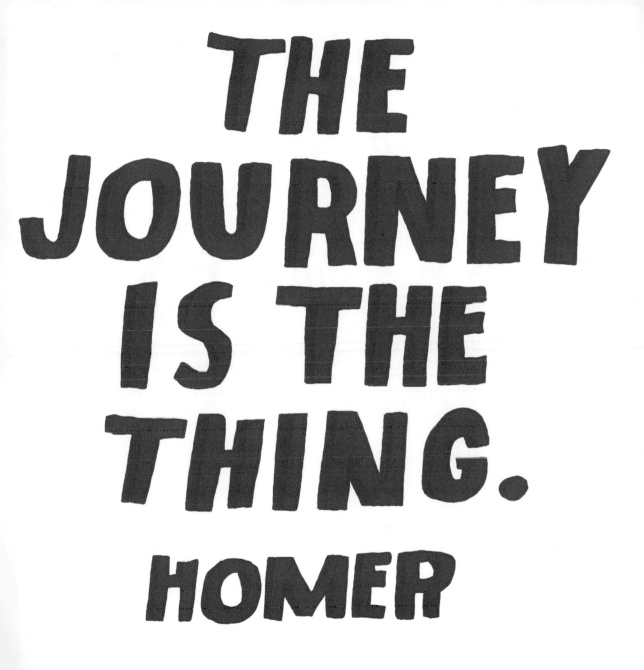

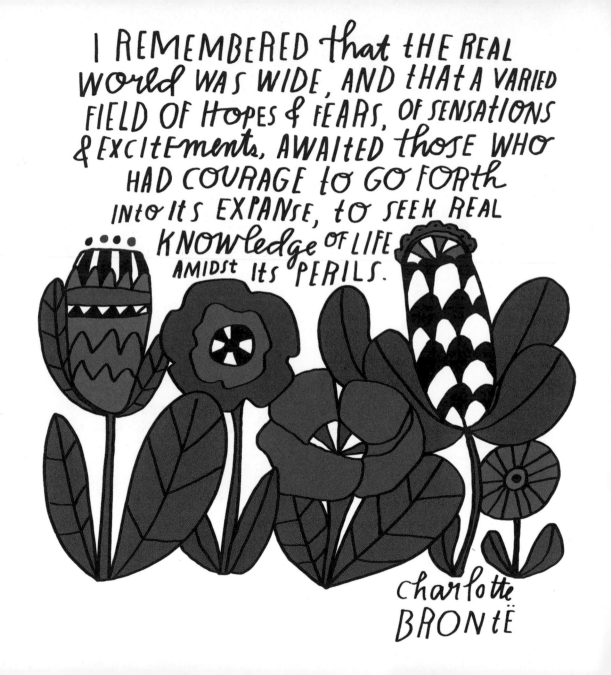

LET US ACCEPT tRUth,
EVEN WHEN It SURPRISES US
AND ALtERS OUR VIEWS.
GEORGE SAND

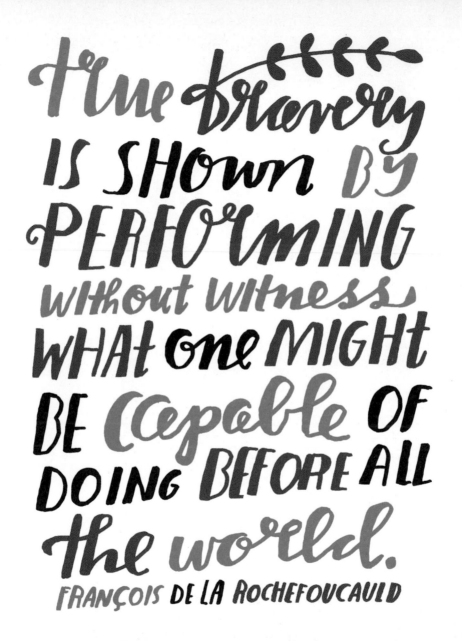

True bravery is shown by performing without witness what one might be capable of doing before all the world.

FRANÇOIS DE LA ROCHEFOUCAULD

BEWARE;
FOR I AM FEAR
LESS,
AND THEREFORE
POWERFUL.
MARY SHELLEY

THERE IS A STUBBORNNESS
ABOUT ME THAT NEVER CAN
BEAR to BE FRIGHTENED AT
the WILL OF OTHERS. MY
COURAGE ALWAYS RISES
WITH EVERY ATTEMPT to
INTIMIDATE ME.

JANE AUSTEN

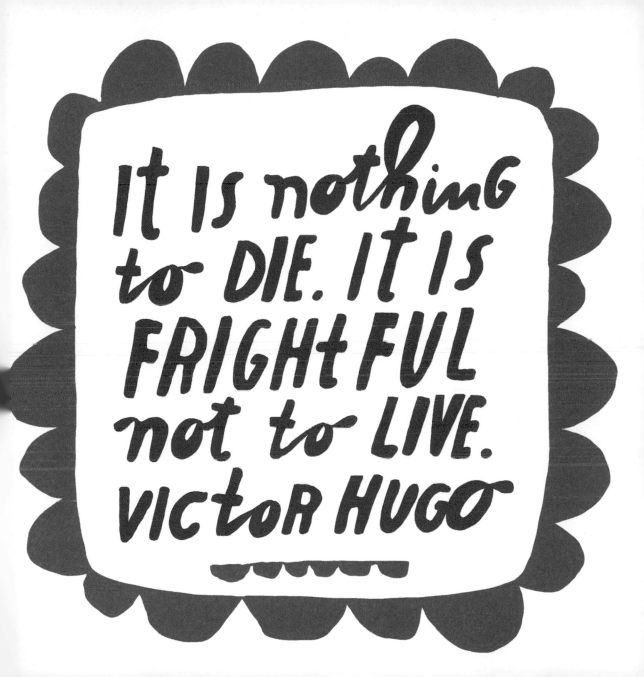

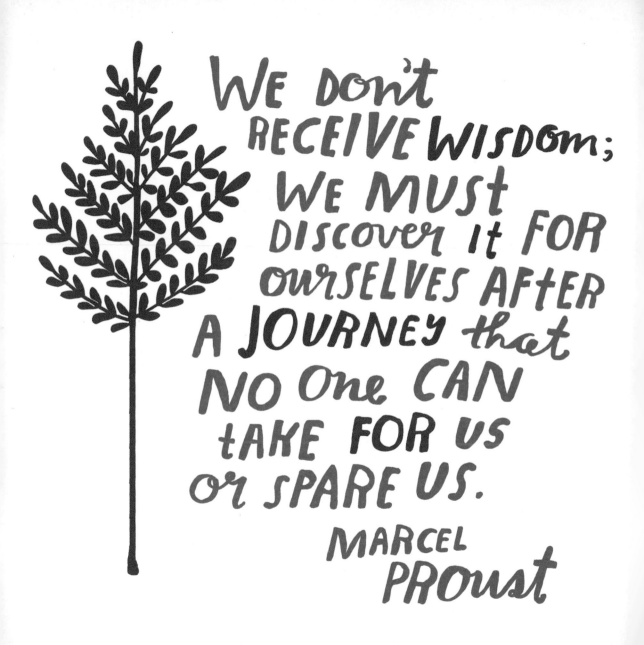

WE don't
RECEIVE WISDOM;
WE MUST
DISCOVER IT FOR
OURSELVES AFTER
A JOURNEY that
NO One CAN
take FOR US
OR SPARE US.
MARCEL
PROUST

IN YOURSELF
RIGHT NOW IS
ALL THE PLACE
YOU'VE GOT.

FLANNERY O'CONNOR

THE SNOW GOOSE NEED NOT BATHE TO MAKE ITSELF WHITE. NEITHER NEED YOU DO ANYTHING BUT BE YOURSELF.

LAO TZU

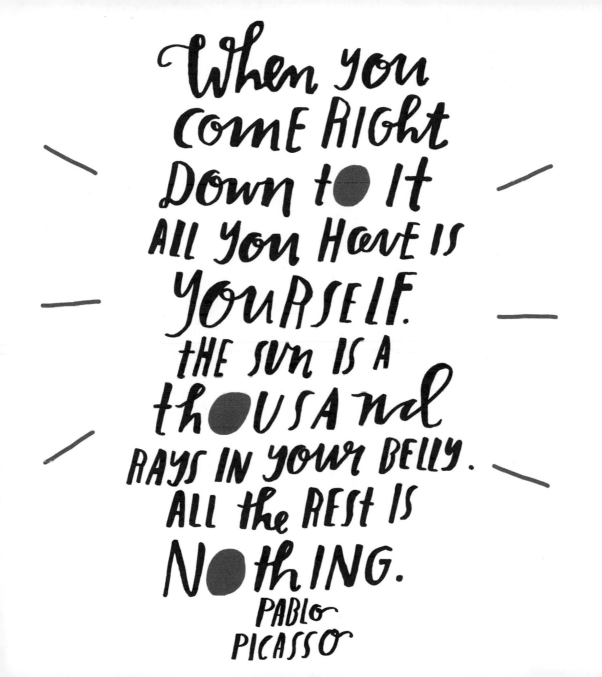

When you
come right
down to It
all you have is
yourself.
the sun is a
thousand
rays in your belly.
all the rest is
nothing.
PABLO
PICASSO

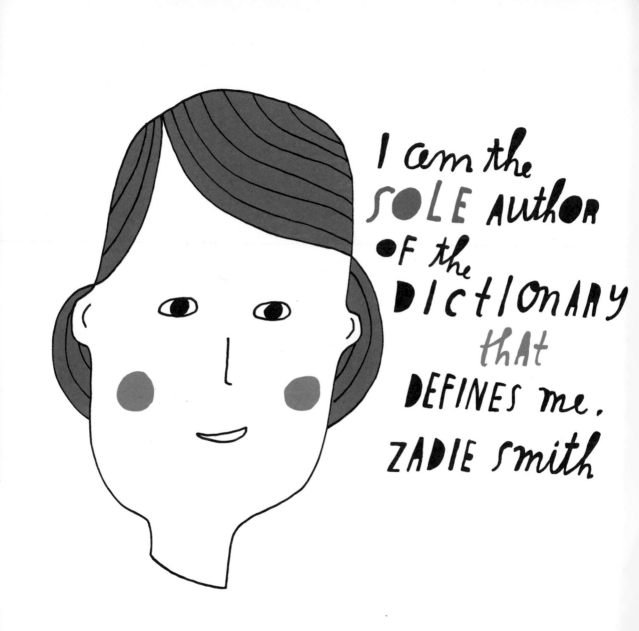

I am the SOLE Author OF the DICTIONARY that DEFINES me.

ZADIE Smith

DEFINITIONS BELONGED TO THE DEFINERS, NOT THE DEFINED.

TONI MORRISON

IF YOU'RE IN PITCH BLACKNESS, ALL YOU CAN DO IS SIT TIGHT UNTIL YOUR EYES GET USED TO THE DARK. HARUKI MURAKAMI

WE, UNACCUSTOMED tO COURAGE
EXILES FROM DELIGHt
LIVE COILED IN SHELLS OF LONELINESS
UNtIL LOVE LEAVES its HIGH
HOLY tEMPLE
AND COMES INtO OUR SIGHt
tO LIBERAtE US INtO LIFE.
MAYA
ANGELOU

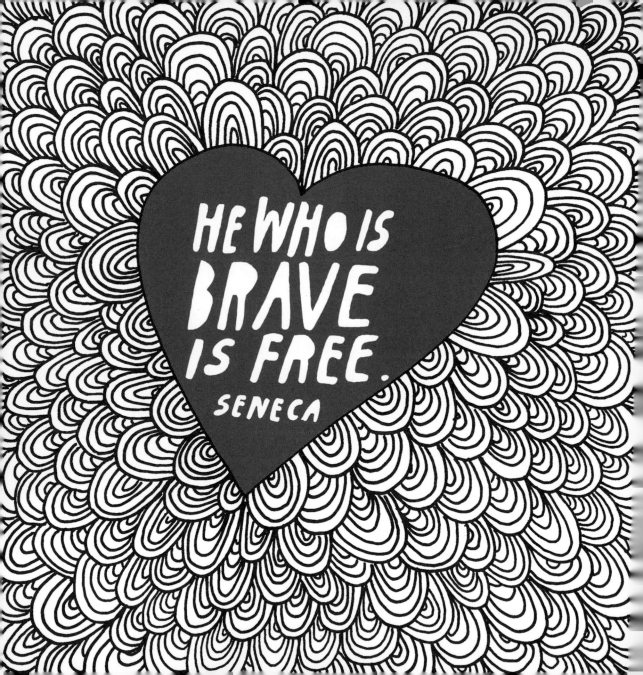

IT IS PERFECTLY TRUE, AS
PHILOSOPHERS SAY, THAT
LIFE MUST BE UNDERSTOOD
BACKWARDS. BUT THEY
FORGET THE OTHER
PROPOSITION, THAT IT
MUST BE LIVED FORWARDS.
SØREN KIERKEGAARD

LIVE!
LIVE THE WONDERFUL
LIFE THAT IS IN
YOU! LET NOTHING
BE LOST UPON
YOU.
BE ALWAYS SEARCHING
FOR NEW
SENSATIONS.
BE AFRAID OF
NOTHING.
OSCAR WILDE

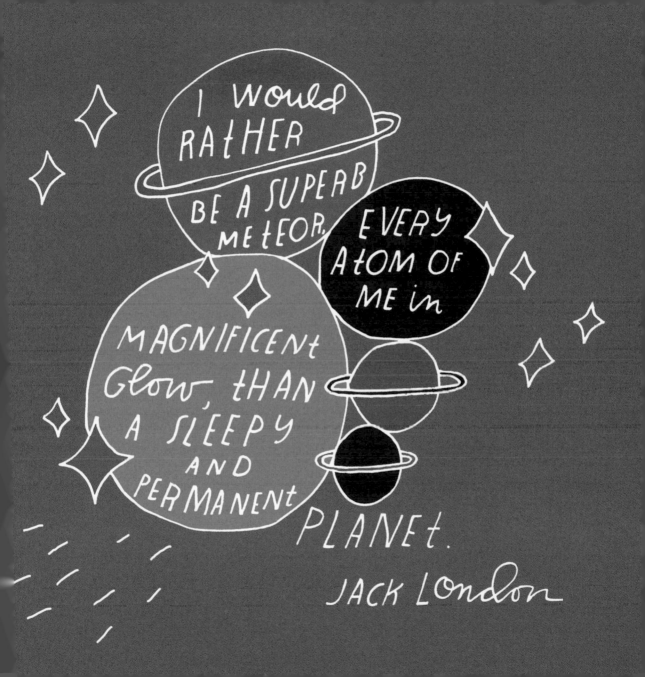

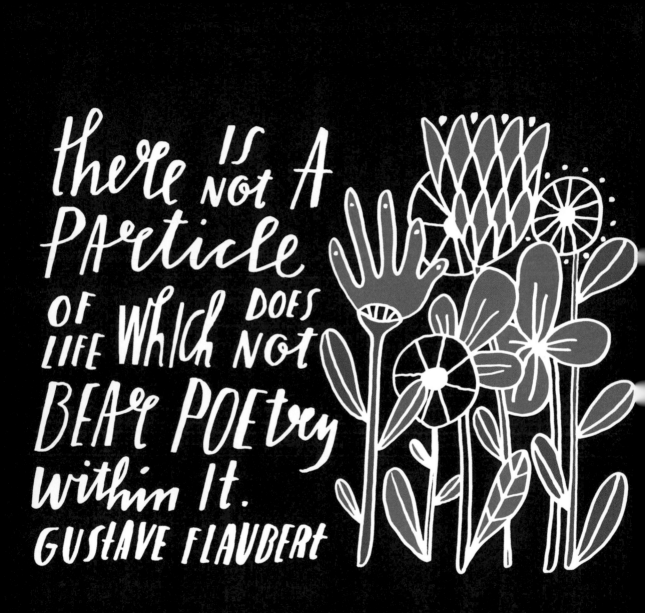

there is not A particle of life which does not BEAr POEtry within It.
GUStAVE FLAUBERT

ALL THE VARIETY,
ALL THE CHARM,
ALL THE BEAUTY
OF LIFE IS
MADE UP OF
LIGHT AND SHADOW.
LEO TOLSTOY

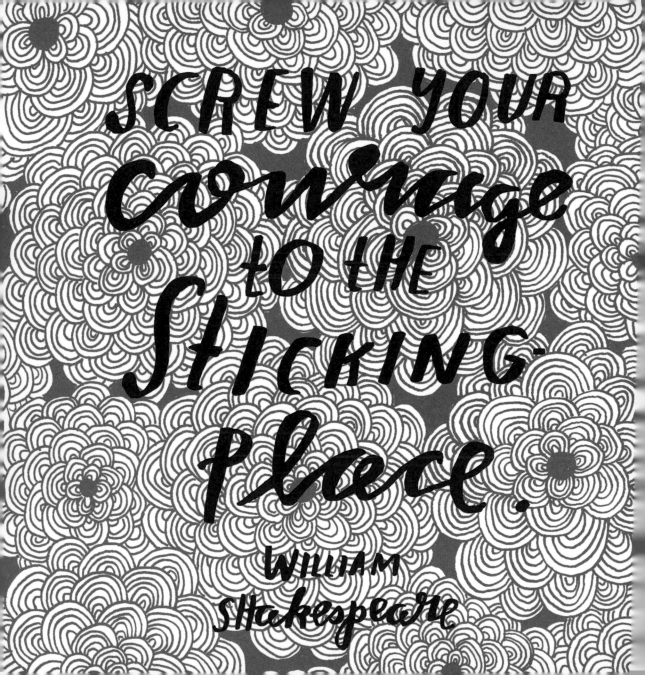

WHEN YOU GET INTO A TIGHT PLACE AND EVERYTHING GOES AGAINST YOU UNTIL IT SEEMS THAT YOU CANNOT HOLD ON FOR A MINUTE LONGER, NEVER GIVE UP THEN, FOR THAT IS JUST THE PLACE AND TIME WHEN THE TIDE WILL TURN.

HARRIET BEECHER STOWE

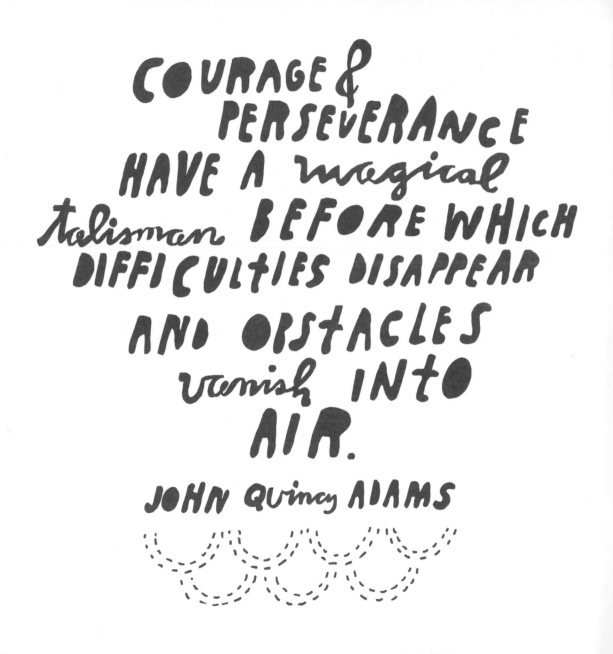

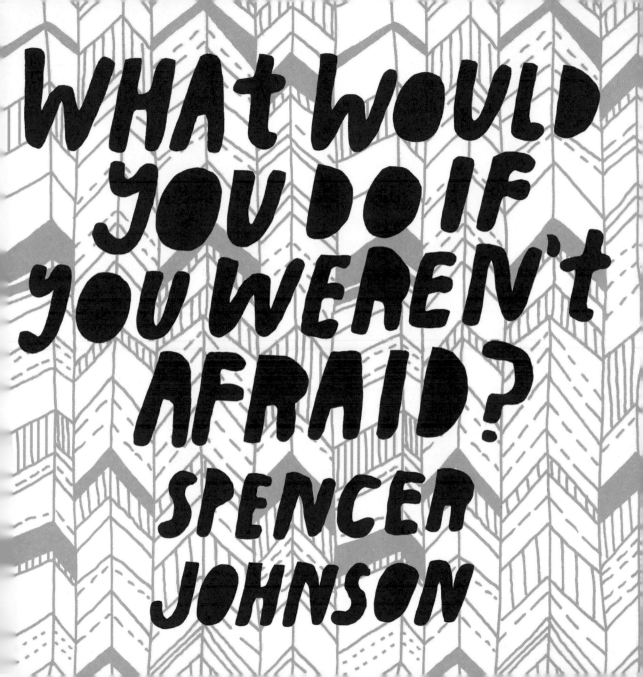

to l♥ve someone fiercely, to believe in something with your whole heart, to celebrate a fleeting moment in time, to fully engage in a life that doesn't come with guarantees – these are risks that involve vulnerability and often pain... I'm learning that recognizing and leaning into the discomfort of vulnerability teaches us how to live with joy, gratitude, and grace. ♥ BRENÉ BROWN

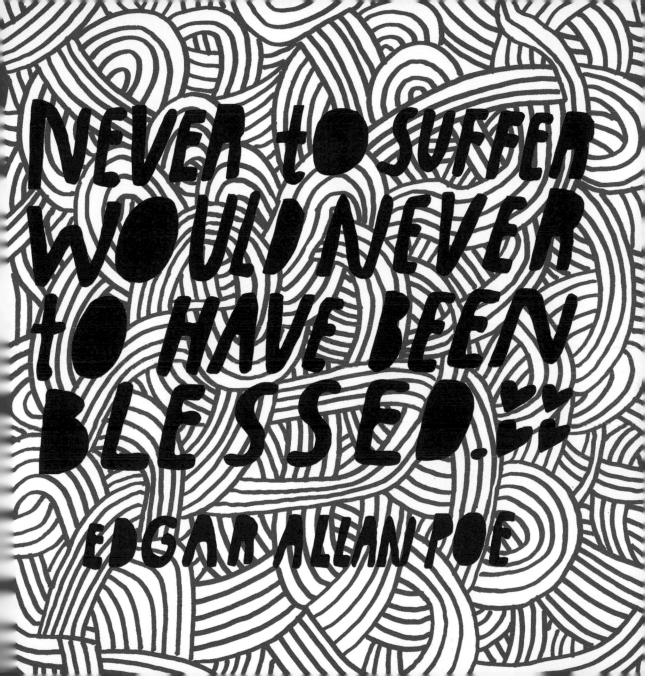

NEVER to SUFFER WOULD NEVER to HAVE BEEN BLESSED.

EDGAR ALLAN POE

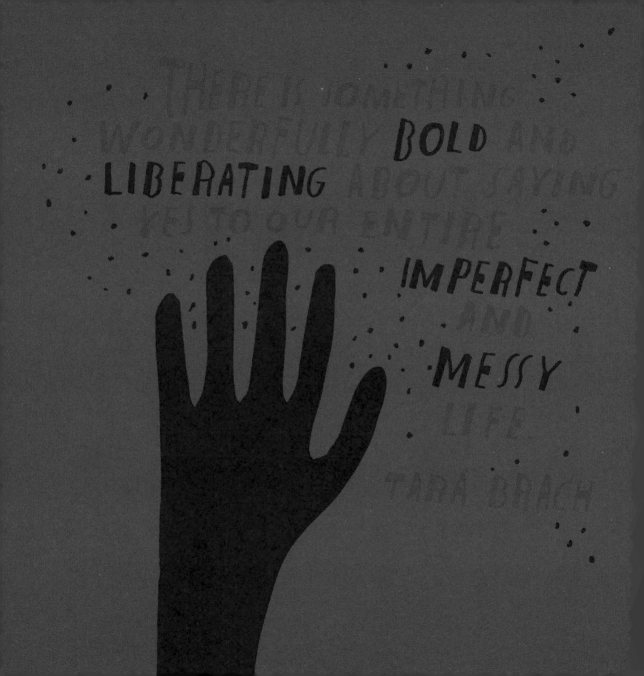

THERE IS SOMETHING WONDERFULLY BOLD AND LIBERATING ABOUT SAYING YES TO OUR ENTIRE IMPERFECT AND MESSY LIFE.

TARA BRACH

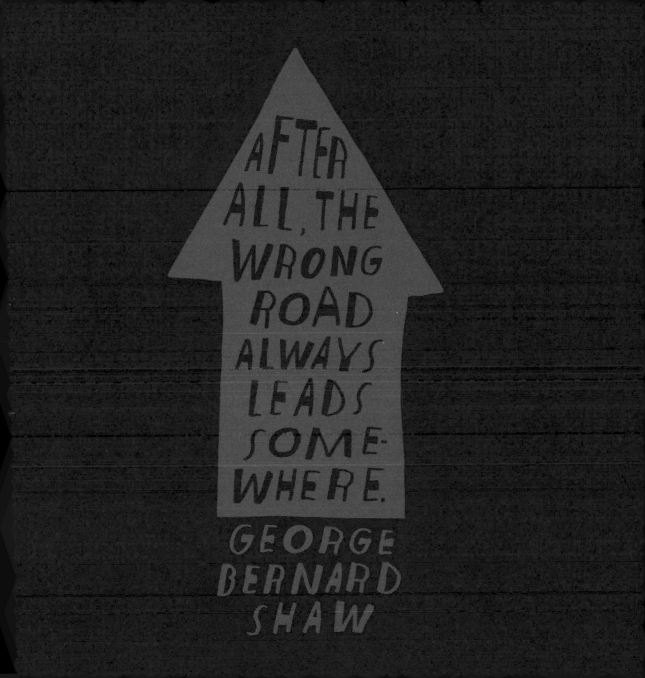

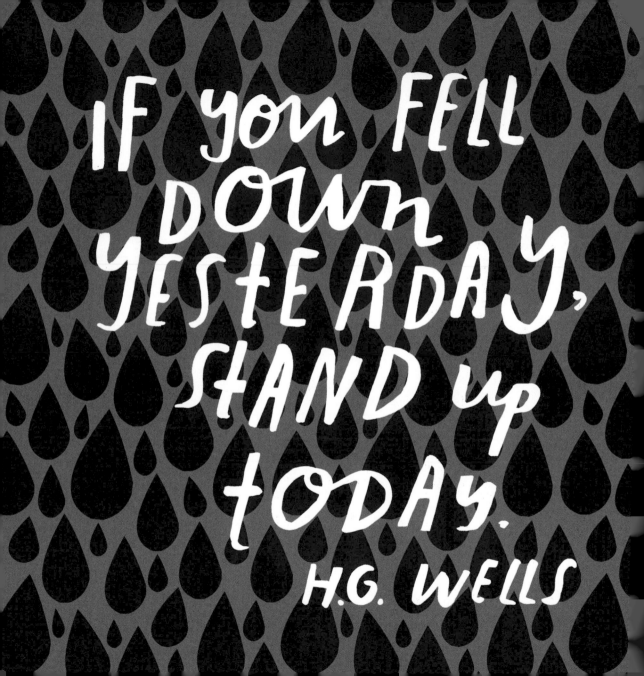

IF you FELL DOWN YESTERDAY, STAND up today.

H.G. WELLS

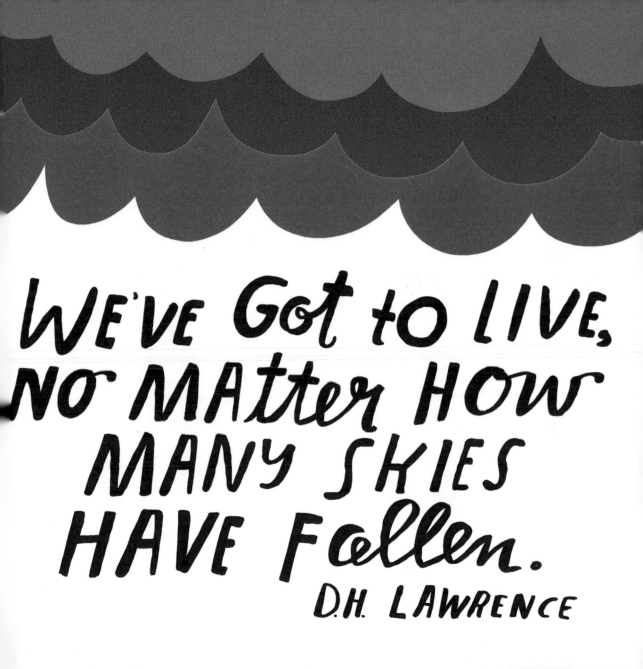

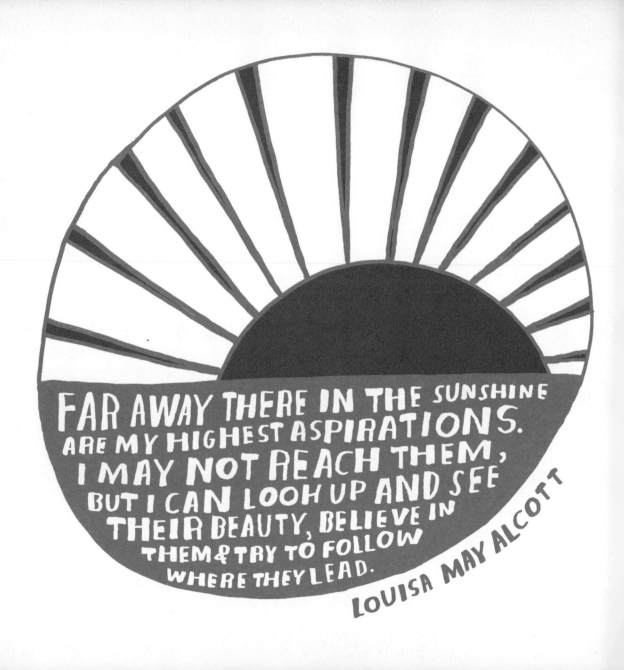

FAR AWAY THERE IN THE SUNSHINE ARE MY HIGHEST ASPIRATIONS. I MAY NOT REACH THEM, BUT I CAN LOOK UP AND SEE THEIR BEAUTY, BELIEVE IN THEM & TRY TO FOLLOW WHERE THEY LEAD.

LOUISA MAY ALCOTT

THERE ARE SEASONS,
IN HUMAN AFFAIRS, OF inward
AND OUTWARD REVOLUTION,
WHEN NEW DEPTHS SEEM
TO BE BROKEN UP IN THE
soul, WHEN NEW WANTS
ARE UNFOLDED IN MULTITUDES,
AND A new AND UNDEFINED
GOOD IS THIRSTED FOR.
THESE ARE PERIODS WHEN...
TO DARE IS THE HIGHEST
WISDOM.

WILLIAM ELLERY CHANNING

DON'T
PASS IT BY—
the IMMEDIATE,
THE REAL, the ONLY,
the YOURS.

HENRY
JAMES.

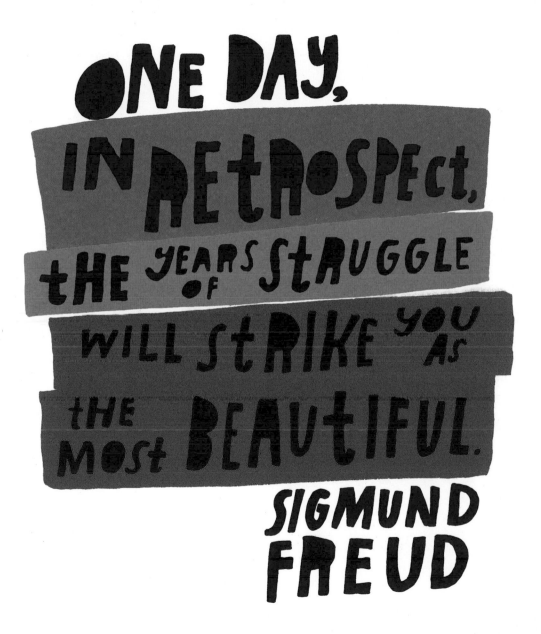

ONE DAY, IN RETROSPECT, THE YEARS OF STRUGGLE WILL STRIKE YOU AS THE MOST BEAUTIFUL.

SIGMUND FREUD

WE CAST A SHADOW ON
SOMETHING WHEREVER
WE STAND, AND IT IS NO
GOOD MOVING FROM
PLACE TO PLACE TO SAVE
THINGS; BECAUSE THE
SHADOW ALWAYS FOLLOWS.
CHOOSE A PLACE WHERE
YOU WON'T DO HARM...
AND STAND IN IT FOR
ALL YOU ARE WORTH,
FACING THE SUNSHINE.
E.M. FORSTER

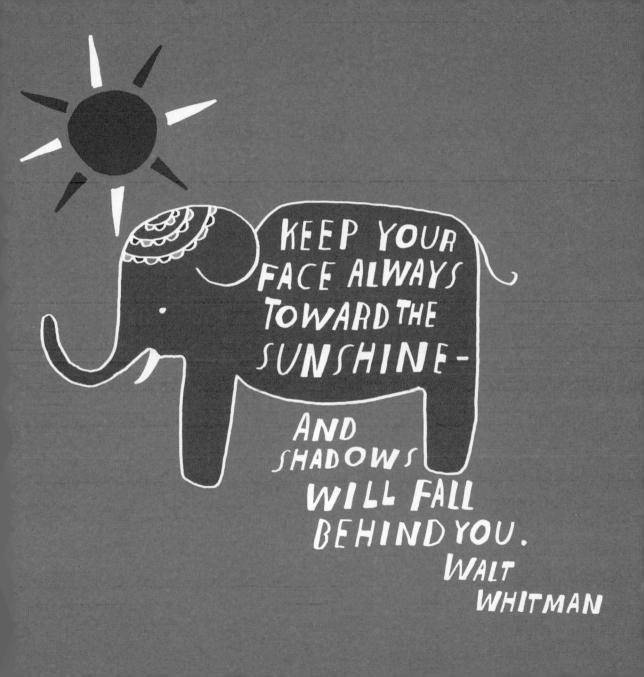

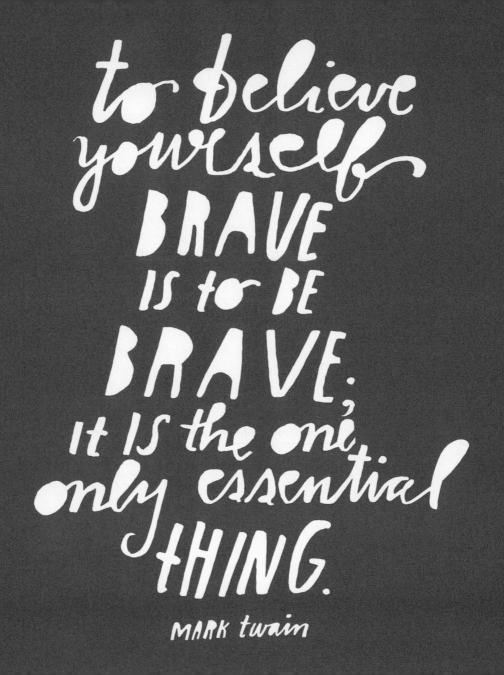

to believe
yourself
BRAVE
is to BE
BRAVE.
It is the one
only essential
THING.

MARK twain

A KIND OF
LIGHT SPREAD OUT FROM
HER. AND EVERYthing CHANGED
COLOR. AND the WORLD OPENED
OUT. AND A DAY WAS GOOD to
AWAKEN to. AND there WERE NO
LIMITS to ANYthing. AND the
PEOPLE of THE WORLD WERE
GOOD & HANDsome. AND
I WAS NOt AFRAID
ANY more.

JOHN
STEINBECK

HE FELT READY to
FACE THE DEVIL,
AND STRUTTED
IN the BALLROOM
WITH THE SWAGGER
OF A CAVALIER.
ROBERT LOUIS STEVENSON

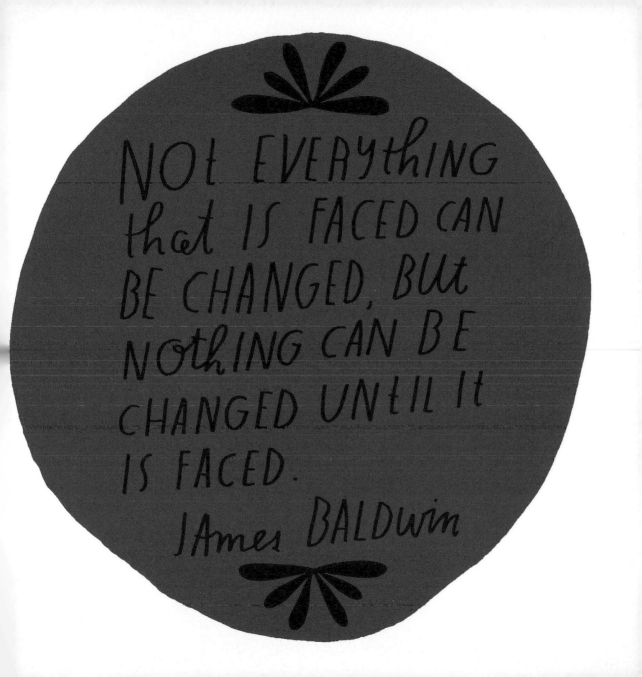

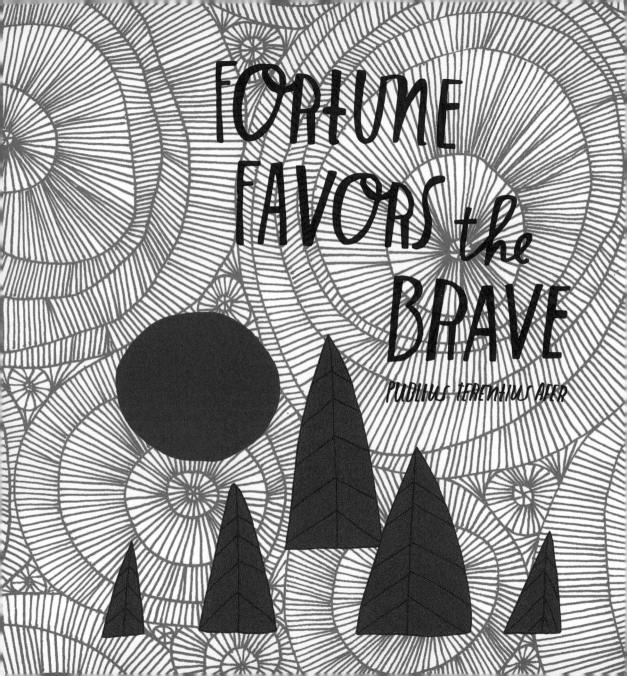

WE NEVER KNOW HOW HIGH WE ARE
till WE ARE CALLED tO RISE;
AND thEN, IF WE ARE tRUE tO PLAN
OUR statURES tOUCH thE SKIES—

thE HEROISM WE RECItE
WOULD BE A DAILY thING,
DID NOt OURSELVES thE CUBItS WARP
FOR FEAR tO BE A KING.

EMILY DICKINSON

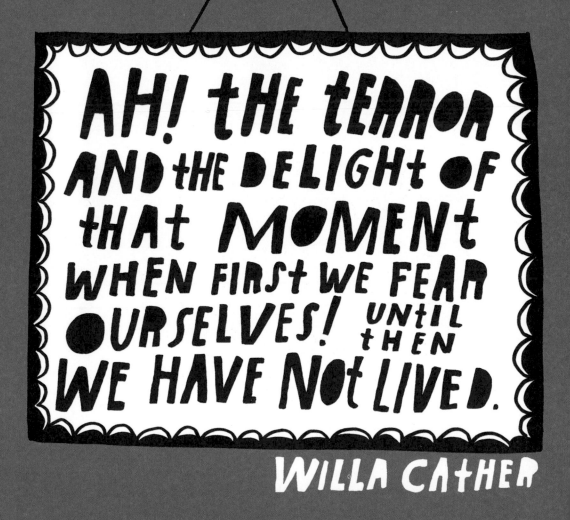

AH! THE TERROR AND THE DELIGHT OF THAT MOMENT WHEN FIRST WE FEAR OURSELVES! UNTIL THEN WE HAVE NOT LIVED.

WILLA CATHER

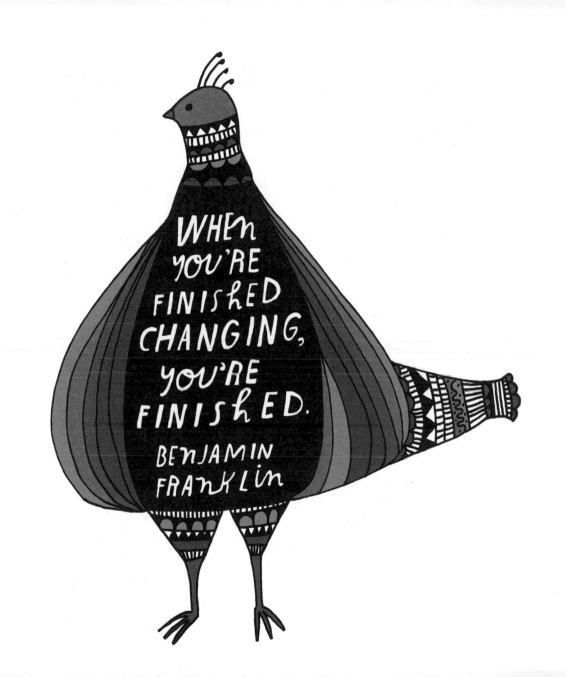

ONE RESOLUTION I HAVE MADE, AND TRY ALWAYS TO KEEP, IS THIS: "TO RISE ABOVE THE LITTLE THINGS."

JOHN BURROUGHS

I LOVE tHOSE WHO YEARN FOR tHE IMPOSSIBLE.

JOHANN WOLFGANG VON GOETHE

THERE IS NO MEDICINE LIKE HOPE, NO INCENTIVE SO GREAT, AND NO TONIC SO POWERFUL AS EXPECTATION OF SOMETHING TOMORROW.

O.S. MARDEN

there's A POINT,
AROUND the AGE OF
twenty, WHEN YOU
HAVE to CHOOSE
WHETHER to BE
LIKE EVERYBODY
Else the REST OF YOUR
LIFE, OR to MAKE A
VIRTUE OF your
PECULIARITIES.

URSULA K. LE GUIN

TWO or THREE THINGS
I KNOW FOR SURE,
AND ONE IS THAT I'D
RATHER GO NAKED than
WEAR the COAt THE
WORLD HAS MADE
FOr ME.

DOROthy ALLISON

BUT HOW COULD YOU LIVE AND HAVE NO STORY TO TELL?

FYODOR DOSTOYEVSKY

BE TRUE!
BE TRUE!
BE TRUE!

NATHANIEL
HAWTHORNE

IT IS HARD WORK AND GREAT ART tO MAKE LIFE NOt SO SERIOUS.

JOHN IRVING

there are times to stay put, and what you want will come to you, and there are times to go out into the world and find such a thing for yourself.

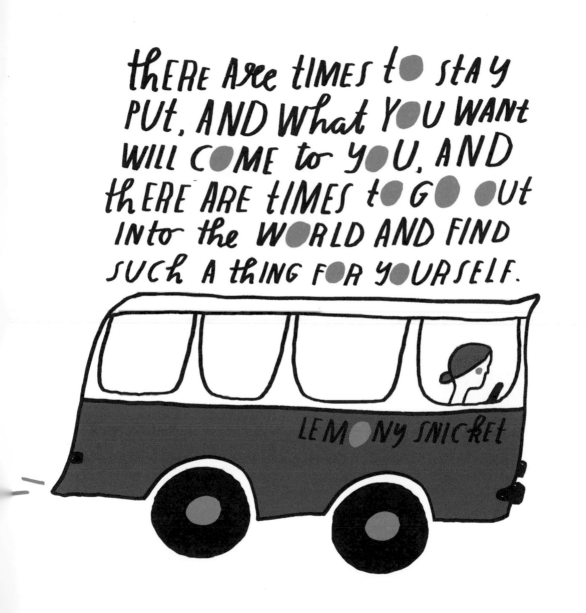

LEMONY SNICKET

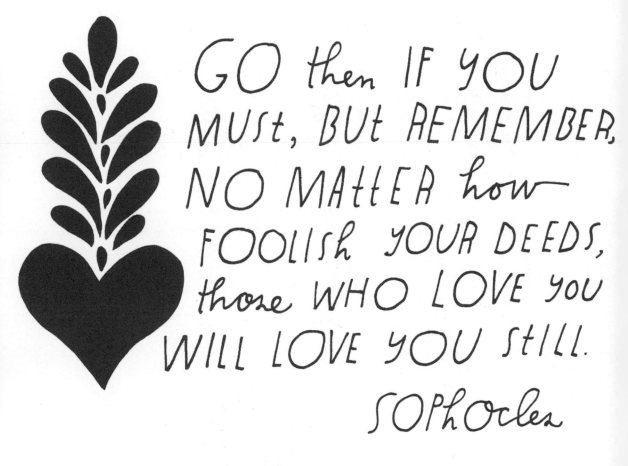

GO then IF YOU MUST, BUT REMEMBER, NO MATTER how FOOLISH YOUR DEEDS, those WHO LOVE YOU WILL LOVE YOU STILL.

SOPhOCles

I ALWAYS FELT THAT
THE GREAT HIGH
PRIVILEGE, RELIEF &
COMFORT OF
FRIENDSHIP WAS
THAT ONE HAD TO
EXPLAIN NOTHING.
KATHERINE MANSFIELD

But whatever came, she HAD Resolved NEVER AGAIN to BElong tO Another tHAN HERself. KAte CHOPIN

WHATEVER HAPPENS
TO YOU BELONGS TO
YOU. MAKE IT YOURS.
FEED IT TO YOURSELF EVEN
IF IT FEELS IMPOSSIBLE
TO SWALLOW. LET IT
NURTURE YOU, BECAUSE
IT WILL. CHERYL STRAYED

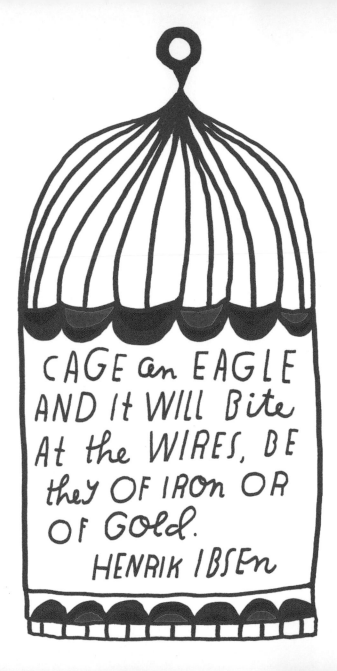

CAGE an EAGLE AND It WILL Bite At the WIRES, BE they OF iROn OR OF Gold.

HENRIK IBSEN

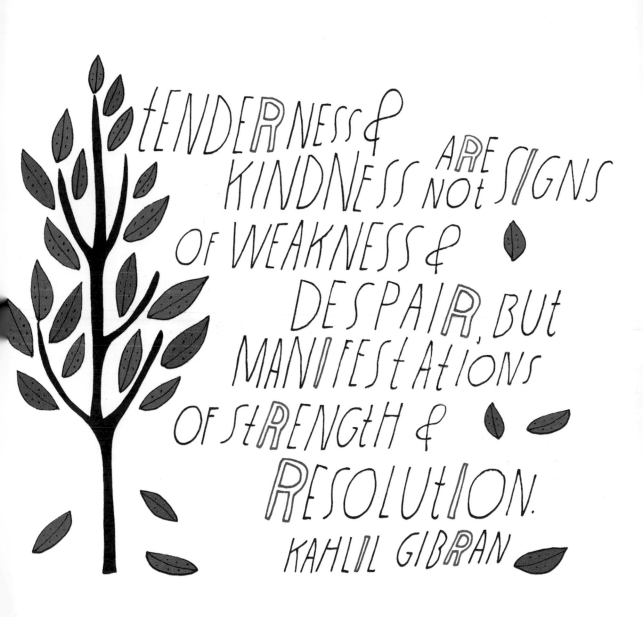

tENDERNESS & KINDNESS ARE NOT SIGNS OF WEAKNESS & DESPAIR, BUt MANIFEStAtIONS OF StRENGtH & RESOLUtION. KAHLIL GIBRAN

BRAVERY NEVER GOES out OF FASHION.

WILLIAM MAKEPEACE THACKERAY

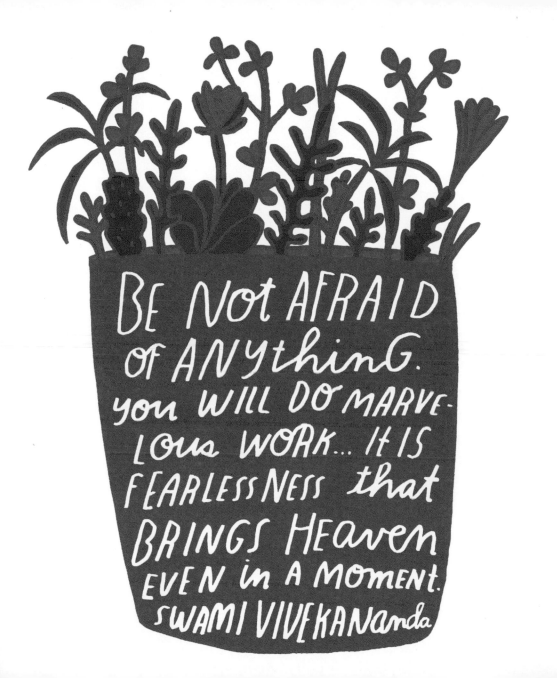

GIRD YOUR HEARTS WITH SILENT FORTITUDE, SUFFERING, YET HOPING FOR ALL THINGS.

FELICIA HEMANS

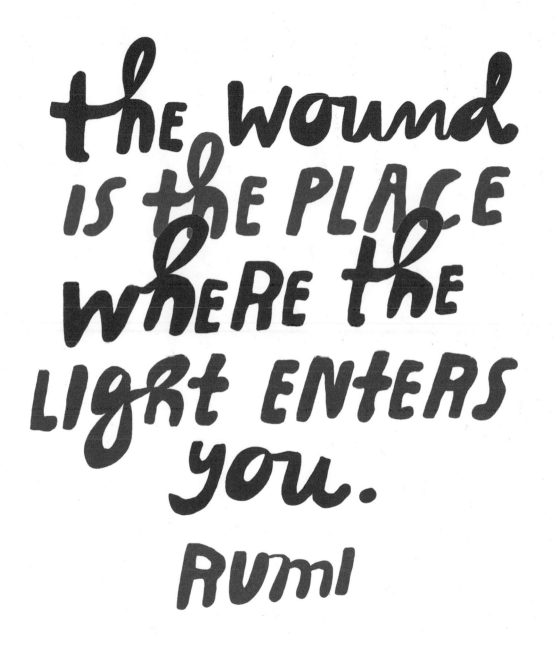

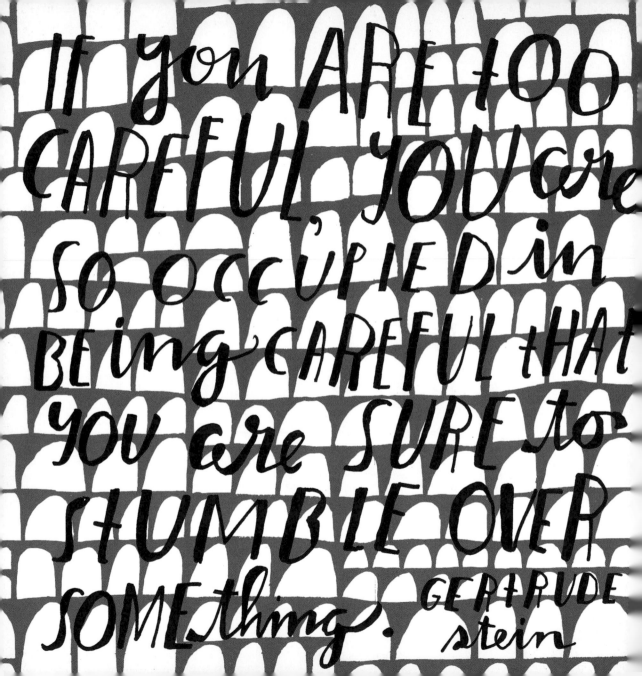

IF YOU ARE TOO CAREFUL, YOU are SO OCCUPIED in BEING CAREFUL tHAt YOU are SURE to STUMBLE OVER SOMEthing. GERtRUDE stein

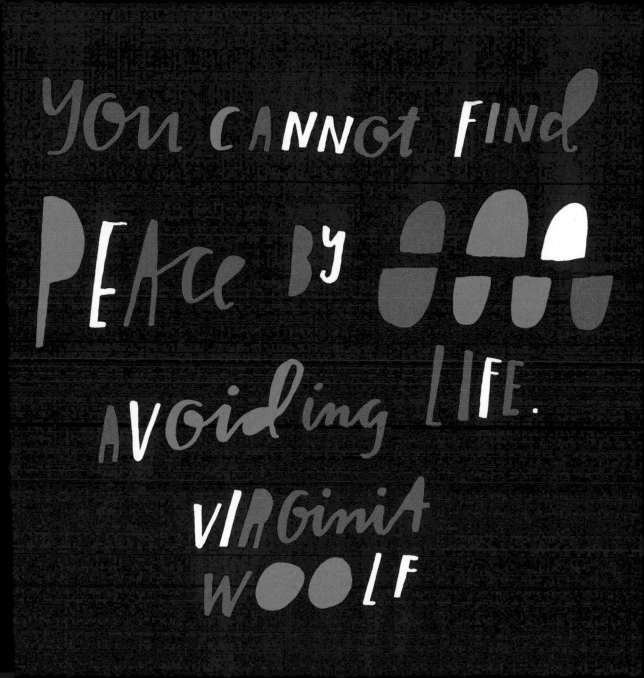

YOU CANNOT FIND

PEACE BY

AVOiding LIFE.

VIRGiniA

WOOLF

COURAGE IS the PRICE that LIFE EXACTS FOR GRANTING PEACE.

Amelia EARHART

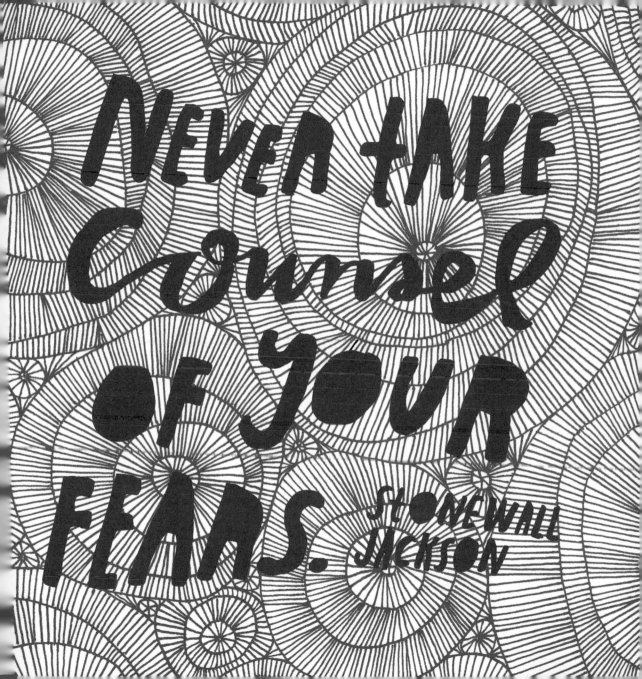

NEVER TAKE COUNSEL OF YOUR FEARS.

STONEWALL JACKSON

She Made herself stronger by fighting with the wind.

FRANCES Hodgson Burnett

THERE ARE VERY FEW
HUMAN BEINGS WHO
RECEIVE THE TRUTH,
COMPLETE and STAGGERING,
BY INSTANT ILLUMINATION.
MOST OF THEM ACQUIRE
IT FRAGMENT BY FRAGMENT,
ON A SMALL SCALE, BY
SUCCESSIVE DEVELOPMENTS
CELLULARLY, LIKE A
LABORIOUS MOSAIC.

ANAÏS NIN

NERVOUS MEANS YOU WANT TO PLAY. SCARED MEANS YOU DON'T WANT TO PLAY. SHERMAN ALEXIE

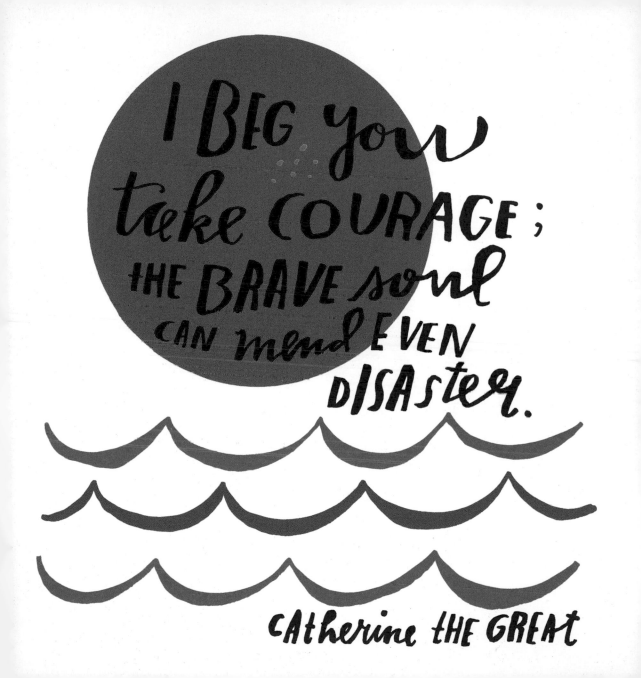

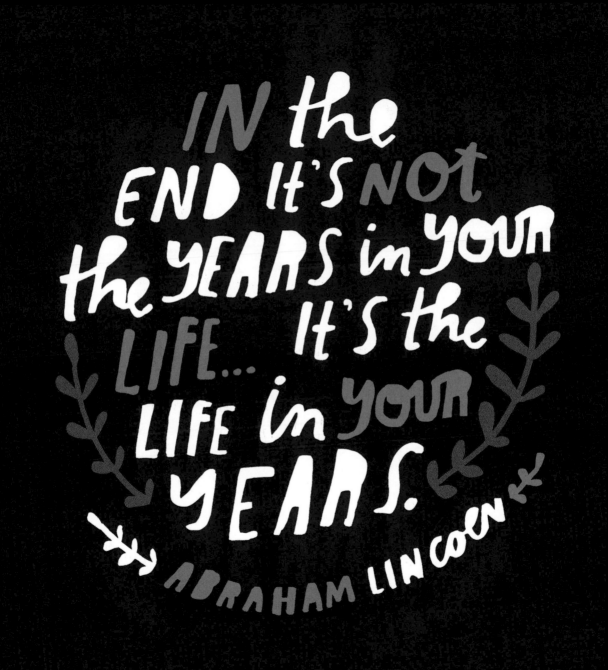

Quotation Credits

All quotations not listed are in the public domain.

..

"I suspect the truth is that we are waiting, all of us, against insurmountable odds, for something extraordinary to happen to us." –Khaled Hosseini. From *And the Mountains Echoed*, 2013, used by permission of author.

"The truth is humbling, terrifying, and often exhilarating. It blows the doors off the hinges and fills the world with fresh air." –Augusten Burroughs.*This Is How: Surviving What You Think You Can't.* Copyright © 2012 by Augusten Burroughs. Published by permission of Augusten Burroughs c/o Selectric Artists LLC.

"To be fully alive, fully human, and completely awake is to be continually thrown out of the nest. To live fully is to be always in no-man's-land, to experience each moment as completely new and fresh. To live is to be willing to die over and over again. " –Pema Chödrön. Excerpt from *When Things Fall Apart*, by Pema Chödrön, ©1997 by Pema Chödrön. Reprinted by arrangement with The Permissions Company, Inc., on behalf of Shambhala. Publications Inc., Boston, MA. www.shambhala.com.

"If I could believe in myself, why not give other improbabilities the benefit of the doubt?" –David Sedaris. Reprinted by permission of the author and Don Congdon Associates, Inc. From the story "Jesus Shaves," originally published by *Esquire* and included in *Me Talk Pretty One Day* and *Holidays On Ice* by David Sedaris © by David Sedaris.

"If you are not afraid of the voices inside you, you will not fear the critics outside you." –Natalie Goldberg. Excerpt from *Writing Down the Bones: Freeing the Writer Within*, by Natalie Goldberg, © 1986 by Natalie Goldberg. Reprinted by arrangement with The Permissions Company, Inc., on behalf of Shambhala Publications Inc., Boston, MA. www.shambhala.com.

"you can, you should, and if you're brave enough to start, you will." –Stephen King. From *On Writing* by Stephen King, published by Scribner, an imprint of Simon & Schuster. Copyright © 2000 by Stephen King. Permission granted by the author and his agent, Darhansoff & Verrill. All rights reserved.

"One should go easy on smashing other people's lies. Better to concentrate on one's own."–Iris Murdoch. From *Henry and Cato* by Iris Murdoch. Published by Vintage. Reprinted by permission of The Random House Group Ltd; Henry and Cato © Iris Murdoch